YOUR SKETCHBOOK YOUR SELF

Felicity Allen

Contents

MAKE YOUR SKETCHBOOK YOUR OWN!

There are plenty of things that sketchbooks have in common and top of the list is this:

Each sketchbook is unique and it belongs to a unique artist – that is, you, whoever you are, whatever your age, and whatever you do.

Henri Gaudier-Brzeska gave one of his sketchbooks the title 'Le Chaos' …

Which of Romare Bearden's ideas begin where? Does the cow jumping over the moon link to the man hanging from the balloon? Is the woman a picture of the poet Emily Dickinson 'dwelling in possibility'?

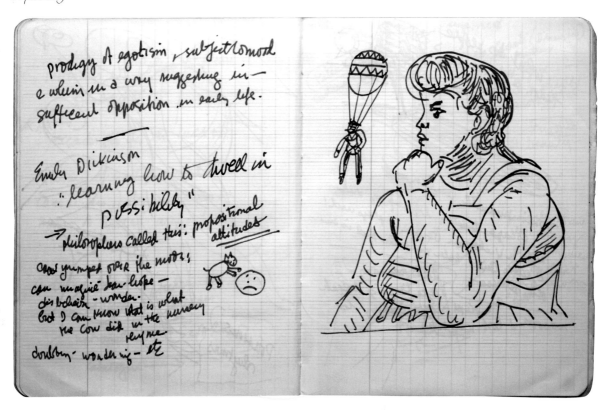

To make a sketchbook do the things you need it to do, you have to let it be almost a part of you; let yourself become attached to it.

When you go out, take it with you, just as you would your phone.

Play with it.

Most of all, care for it.

When you use your sketchbook, it will come to life: nourish it and you'll see your art (or design or photography or film etc.) transformed – and it will help you think through other subjects and ideas.

Getting the sketchbook habit
- add to it frequently – every day, at least once, if only for five minutes
- refer to it whenever you're making or drawing something
- look back at it even when you've started a new one
- keep it safe but don't get too precious about it
- take it with you most places you go
- share with it what you're thinking and seeing

Make it feel right for you
If possible, choose your own book. Otherwise, make sure you make it FEEL RIGHT for you. If the paper isn't quite right, stick in some that is, and use that.

Is your pencil right? Too hard? Too smudgy? The lines it makes – too thin or too fat? Or, today, do you want scratchy pen and ink, smooth roller ball, unpredictable ballpoint? Choose the pen or pencil that feels right most of the time but, sometimes, try something different.

Keep it with your sketchbook. How will you do this? Tucked under an elastic band around the book can work, or try clipping a pen onto the cover. If you're using a pencil, make sure you have a sharpener with you too. Ideally, you need a tin for a choice of pencils (from medium hard to soft), a sharpener or knife, a rubber (there are different types – choose the one that suits you and your materials best), and one or two pens. You could also add a stick of glue, and a few watercolour pencils, or compressed charcoal (but only if you enjoy the mess).

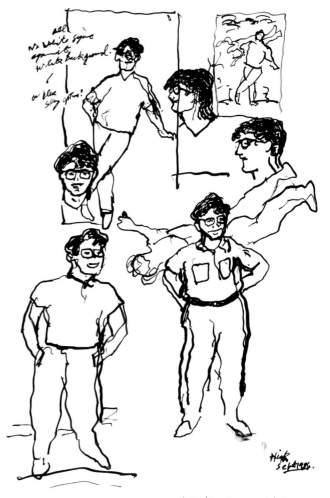

Derek Boshier draws Nick in different positions and aspects, and at different scales. Below, I've experimented with different pens, pencils, charcoal and conté.

Make up your own rules.

Include whatever you want.

Collect, collate, collage.

Write, draw, photograph, print.

Plan, add.

Offload, download.

Cornelia Parker uses writing
to develop her ideas, as well as
sketches. Compare her drawings
on this page with Leonardo's
sketches opposite.

Claude Monet was known as a leading
Impressionist and, in his long life, he
helped pave the way for twentieth-century
Abstract Expressionist artists. When you see
his sketchbook landscapes you can see how
he developed his own pictorial shorthand to
describe trees and landscape. Compare this
with Cornelia Parker's 'shorthand', which is
both drawn and written.

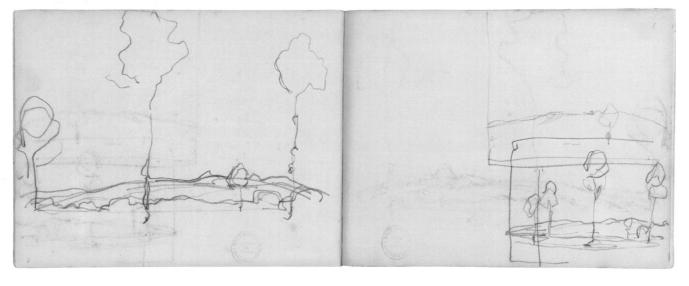

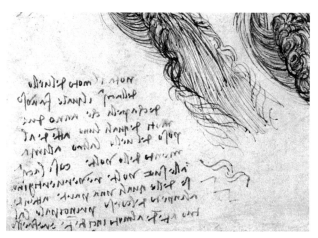

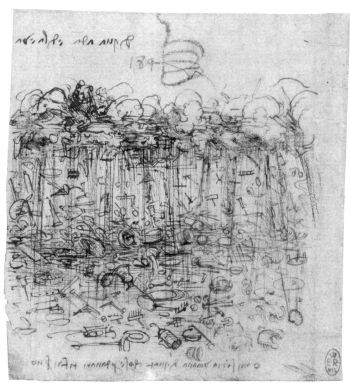

The Italian Renaissance artist Leonardo da Vinci famously developed a special code of mirror writing so that only he could read what he'd written in his sketchbooks. These were wide-ranging, containing detailed scientific observational studies, as well as pictures entirely from his imagination. This cloudburst of material possessions was made five hundred years ago, but could have been made this century. Look, for example, at Cornelia Parker's 'Cold Dark Matter: An Exploded View' 1991, or 'Thirty Pieces of Silver' 1988–9.

Yours and yours alone

It's your book. It reflects you, what you see and what you think – and sometimes, through drawing or writing, you discover what you didn't know you were thinking.

Who will you show it to? Sometimes you might be so pleased with what you've done, you can't wait to show someone. Sometimes a teacher will need to see it, perhaps to help you, or as part of an examined assessment. Art schools love good sketchbooks. They make a strong part of a portfolio. This might help motivate you at first, but let yourself go in your sketchbook and you'll want to make them for their own (that is, your own) sake – never mind what school or college thinks.

Artists usually choose to keep their sketchbooks to themselves until well after they've finished with them. They want to be free to discover things, or to put whatever they choose in their sketchbooks, without being judged. Is it good or bad? It doesn't matter, it's your sketchbook.

Letting your mind go free makes the best sketchbook and leads to the best art. If you have an idea, write it or draw it or make it in your sketchbook. Don't stop yourself. Later, when it comes to showing it, you might want to tear bits out or cover pages up, because you want to keep those things to yourself. That's fine, because everyone knows that a sketchbook isn't meant to look perfect and neat. It's the works of art that you want to make perfect (whether messy or neat). A perfect sketchbook is one that shows it's been through the rough and tumble of your mind. The more you've changed things in it, the more a teacher will see that you know how to use a sketchbook – you've made it your own. But don't get rid of something because you think it's not good enough – only if it's something you want to keep private.

Don't censor yourself

Let yourself live with mistakes you've made – they might be useful later on.

THINKING THROUGH DRAWING

Embarrassment

It can feel weird at first to use a sketchbook. It can make you feel self-conscious, embarrassed. Getting over that feeling is an important step towards being a great artist, or designer, or filmmaker, and it's essential to making a sketchbook work for you. In fact, a sketchbook is only 'good' if it does what you want and it works for you. Not one that looks pretty, or neat, or that is full of brilliant drawings. It is one that makes you feel good about your work, keen to do more, and helps you develop your ideas, your knowledge, and the art (or design, etc) that you are going to make.

Sometimes people feel they haven't got any ideas. How can you start drawing without an idea? There are five easy ways to help. And one essential ingredient, which is TRUST. You have to trust that it willl work, at some point. And it will.

Things to do, to think about doing, and do about thinking

1 Make sure you do something in your sketchbook for at least five minutes every day. The minute you have an idea, write it or draw it. Get into the habit of recording any ideas you have. Stick to it. Gradually your ideas will start to flow and you'll want to use it for longer.

2 Doodle. Doodling helps you think and helps you relax at the same time. If you can't get started, listen to some music, or to someone else's conversation (including on the television) and let your hand draw whatever comes out of your pencil. And then let it go further. And further. (Over the page if you like.) Look at what you've done and ask yourself, what do I find most interesting about this? Or, what did I enjoy most about drawing that doodle? And then do another from what you liked best. And then repeat the process.

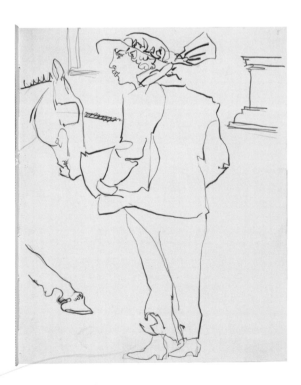

In early sketchbooks Gaudier-Brzeska experimented with drawing quickly from life in pencil, and later drawing over the pencil lines with black ink — it keeps the dynamic quality of quick observation, but also defines the image.

Art comes out of failure. You have to try things out. You can't sit around, terrified of being incorrect, saying 'I won't do anything until I do a masterpiece.'
– John Baldessari (b.1931)

3 **Do some drawings from observation.**
Sit in front of a thing or a person or an animal or a space (inside or outside), and draw it. Do three or four timed drawings – anything between two and ten minutes each one, straight after each other. If you do one for a long time and then you don't like it, it can be quite discouraging. But if you do four quick ones, you'll find you like bits and pieces even if they aren't perfect.

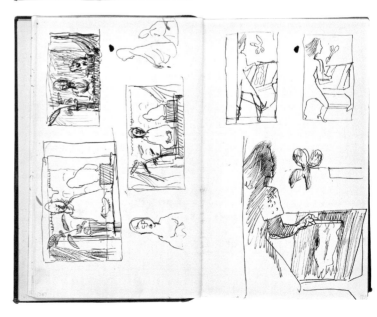

There are several visual ideas that Mark Rothko is developing here. You'll need to look at this book from different angles to see them properly and really work out what he was thinking through these drawings, which are only a few of a larger sequence.

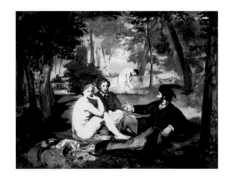

Pablo Picasso continued to draw from other artists' work throughout his career, which lasted most of the twentieth century. Edouard Manet was a very influential nineteenth-century artist, and Picasso's drawings are of one of Manet's most famous paintings, 'Déjeuner sur l'herbe'.

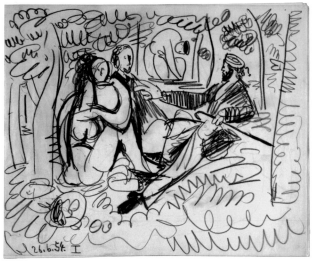

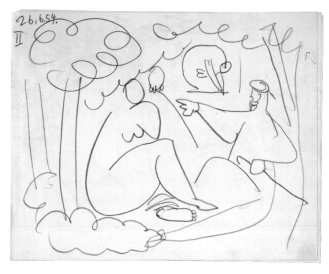

4 Look at a work of art (a real one, if possible in a gallery – it's completely different from looking at a reproduction, and will give you far more to work with). Try drawing from it in your sketchbook. Note down what it's made of, what the colours are and where, draw the shapes and the shadows, note the size and the feel of its weight. As you draw you might notice things you hadn't seen before – write down notes as you see new things. Or you might think about it in a new way – does anything new strike you? Make a note of the ideas in your sketchbook. Try doing some more drawings from the same work, exploring particular bits of it in more detail.

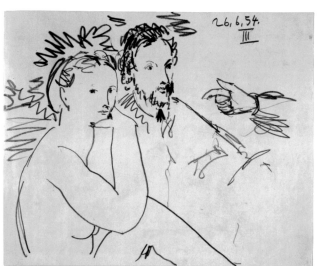

Play. There are many games you can play to experiment with drawing:
- using your left hand if you're right-handed (or vice versa)
- drawing something from observation without looking at the paper
- turning your picture upside down and copying it
- experimenting with different types of lines and marks as you draw
- and all the ideas you've had as you've tried these

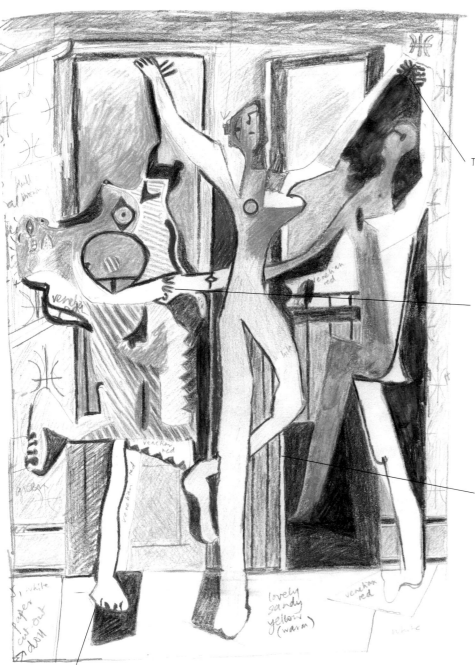

Drawing this, you see how thick the oil paint is in parts: there's a real texture where Picasso has painted over paint that's already dried. The top layer of paint is cracked.

These hands are 'unlocked'.

These hands, especially the little finger, look like they're clutching, hanging on.

This white line runs all the way up the picture. My drawing hasn't matched up properly: this line should fit together behind the figure.

This foot reminds me of an animal's, the toes are like claws, the foot like a paw.

Getting the habit

Once you've done one or two drawings you start getting ideas for the next. Sometimes you might not notice that your ideas have popped up. You have to 'listen' carefully to your thoughts. Or you might think the ideas aren't good enough – but you won't find out unless you try them. Some of the best ideas are developed through drawing, although the voice of reason in your mind might try to persuade you that they're rubbish. Don't listen to it. Let the pencil do the talking. Drawing will often let ideas emerge that you wouldn't think of any other way.

TRYING THINGS OUT

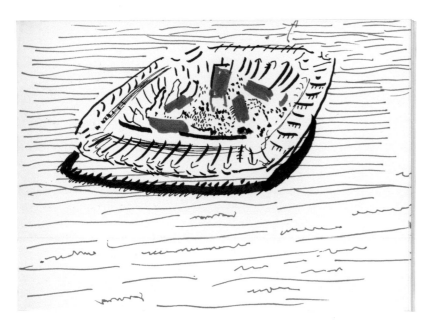

David Hockney draws an ashtray full of cigarette stubs sitting on a table as if it's a sculpture on a plinth. What has he done to indicate the table? It's what's under the ashtray as well as what's around it. What is the ashtray made of? How do you know?

A sketchbook is a container for all the ideas and perceptions that you have.

What should you put in it? Pretty much anything you want to. Remember, DON'T CENSOR YOURSELF!

What do artists and designers put in their sketchbooks?

Drawings
Everything – see all the way through this book.

Collages and other additions
Anything – see pages 28–31 and 40.

Writing
Many things – see pages 32–7.

Consider what Donald Judd would have needed to do between the drawing in his sketchbook and making the red sculpture, 'Untitled' 1963.

Different ways that artists (including you) can draw in sketchbooks

- draw (and paint) from observation
- sketch several versions of the same thing, to try out different ways of seeing it, or concentrate on one bit that takes several drawings to get right
- make a series of drawings from observation to try out completely different ways of interpreting – and developing – what you see
- make a series of drawings of something to reveal the way it changes (e.g. a dancer dancing, or, more slowly, fruit going from ripe to rotten)

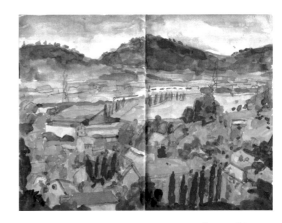

- draw to work out the detail, in preparation for making something you already know you want to make (for instance, a painting, or a sculpture, or an object)
- draw to help you work out how to improve something you've already started, or thought you'd completed (e.g. a painting)
- make some drawings to help you think through some new work that you want to develop from a design or a painting you've already made
- doodle, when you aren't really concentrating on the drawing, to see what emerges
- start to draw something – a head for example – and only start to imagine what it will look like (who it is) as you draw

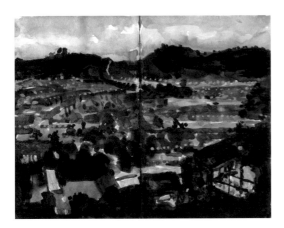

- draw from memory – drawing something can help you work out what really happened, or what you felt about it, or remember more detail so that you can use it in your work – or it can simply be a way of starting an imaginary drawing
- draw to help visualise something you want to make happen (this could be an event, like putting on a performance or a club night)

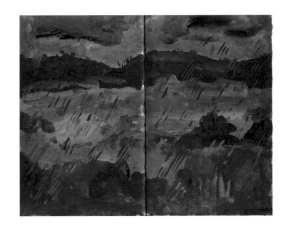

- experiment with abstract drawing, using different shapes
- make a diagram to help think through or describe something
- draw a map to show where you've come from (and how you got here), or where you're going
- draw to analyse, understand, and help remember other pictures or works of art
- draw with the intention of improving your drawing skills and/or powers of observation

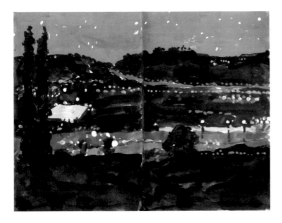

In a small sketchbook Derek Boshier painted Los Angeles from his house in different seasons, at different times, in different weathers.

All of these involve trying things out. You can do this on any piece of paper. So what's special about a sketchbook?

The UNIQUE thing about your sketchbook is that it brings different types of drawing you do all together, along with writing and other pictures. A sketchbook is something to flick through or look back through more carefully. You'll be reminded of things you thought or saw, and you'll see things next to each other that your rational mind – your reasoning – hadn't associated before. From this type of JUXTAPOSITION new things emerge and YOU GET NEW IDEAS.

And quite often you put things together by ACCIDENT or by CHANCE, and you look at them again and see things FRESH.

So trying things out becomes like conducting an EXPERIMENT. You can see different results each time you look back at the sketchbook, because you'll make different connections with what you've already done.

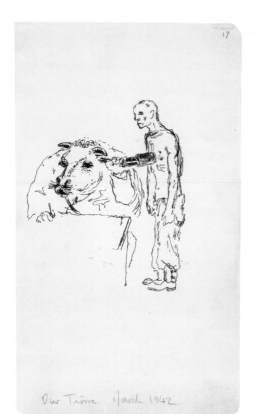

Our Time March 1942

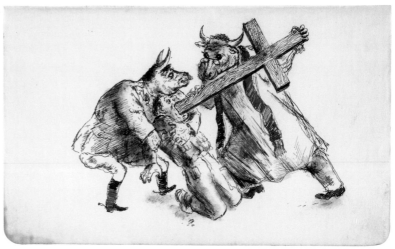

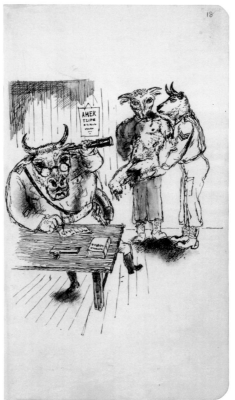

James Boswell served in the British army in the second World War and was stationed in Iraq. His sketchbooks are full of drawings of soldiers and scenes that document the occasions when he was waiting around. Sometimes he drew from observation, sometimes from memory, and sometimes he drew from imagination. Here the real event of the army medical examination of soldiers inspires him to develop symbolic drawings.

Michael Landy's notebooks are full of writing to develop ideas for exhibitions. The writing may occasionally be illustrated by a diagram. Gradually the diagrams increase and the writing decreases.

Sometimes efficiency can get in the way of sketchbook development. You work in one sketchbook for one project, and another for another. This can be useful. However, Michael Landy's sketchbooks show the way some of his preoccupations cross over into different projects – they inform each other, although the final works of art he makes are quite distinct from each other. His sketchbooks show that he continues to think about waste, residue, and destruction – 'To understand value you must study rubbish'.

PACE

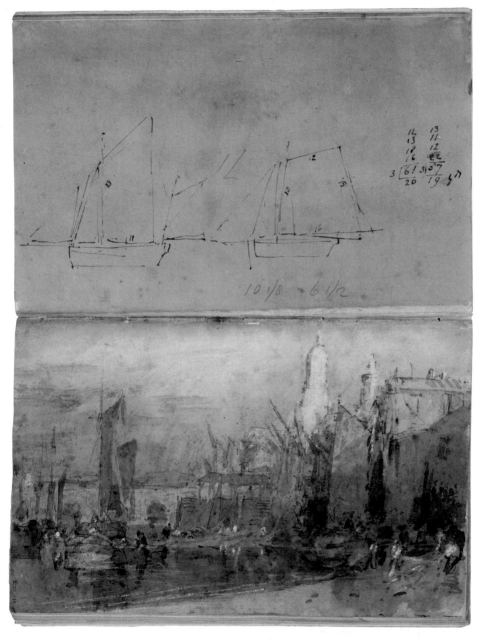

Here J.M.W. Turner made two different types of sketches for different types of information that he needed. One was the painted sketch, which could be the basis for a finished watercolour or a large oil painting – as well as simply practising painting and observing; the other is a more technical drawing which gives him the right information – the proportions, an analysis of how it fits together – again, to paint watercolours and oil paintings.

Look at the drawings in this section. How fast were these artists working? You can see that Turner spent a long time on a single page. He would have been sitting and looking, drawing and painting for, perhaps, an hour. Maybe more.

Observational drawing of this type means Turner would have been constantly looking up at the scene and looking back at the page to draw what he'd just seen. Look up,

look back, draw, look up, look back, draw, over and over again. Every so often stop and look, to check that everything's going in the direction he wants.

On the other hand Picasso was almost scribbling his ideas down as sketches, because his thinking was happening so fast.

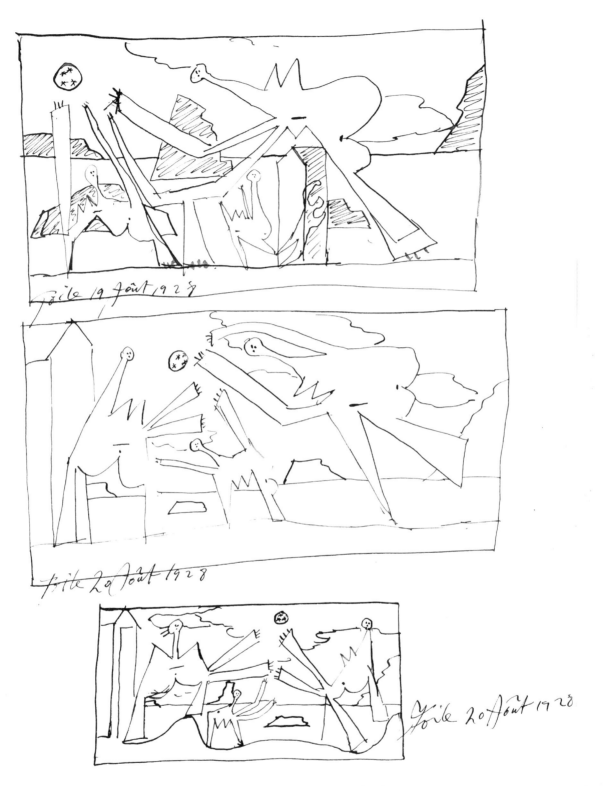

toile 19 Août 1928

toile 20 Août 1928

toile 20 Août 1928

Like other artists, Picasso made many versions of what
looks like the same scene. It could be because he was
trying to get something to look right. Or it could be
because the more he drew the more his thinking leapt,
and so he had to keep drawing to keep pace with his
thinking, and each drawing gave him new thoughts.

Edna Clarke-Hall was drawing fast because she was trying to keep up with the pace of the babies on the move.

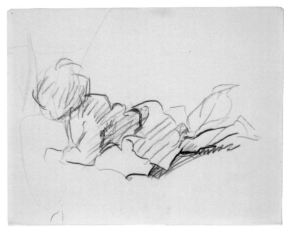

In the picture above you can see a faint green scribble. The artist must have put her sketchbook down, and one of the toddlers has picked it up and tried to copy her drawing. It doesn't detract from Clarke-Hall's drawing, though.

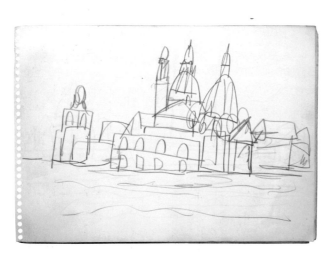

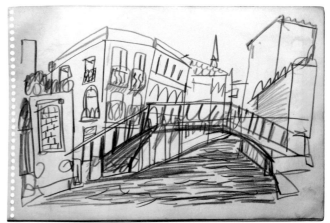

My guess is that Romare Bearden was on a boat when he drew the scene from the sea around Venice, in which case he was drawing fast because he himself was moving.

He may have been on dry land, though, when he drew the Rialto Bridge, or the canal was less choppy.

You can often feel a pace or a rhythm in someone's drawing (try feeling it in your own). It's easy to forget that drawing is physical, and it helps to do some quick first drawings as warm-up exercises.

How and where you put your body in relation to your sketchbook (and the objects you're drawing, if it's from observation) can make all the difference. Sometimes, to capture something, you need to stand, in which case your drawing will probably be quick. You might assume that it's easier to take a photograph, but you'll get a different type of information, and you won't *see* and *remember* nearly as well as if you draw it. Try doing both to compare. Drawing also helps you think about something and understand it.

With a sketchbook it's easy to change your own position to get a different view of something, say, from above or below. You *can* sit at a table but, to get what you want, you might need to lie down, kneel, bend, or stand. However you position yourself, it will change your drawing.

So your sketchbook brings together what's in your mind and your body as it draws. Sometimes your mind gets in the way – for instance, you find it difficult to concentrate. You keep getting distracted, checking the computer or thinking about friends. Some people get up and move around a bit and sit down in a different position. Sometimes you just have to challenge your will power to make you settle down to something. You can try doing several quick drawings that you don't care about, to get yourself going. Look around this book to get more ideas.

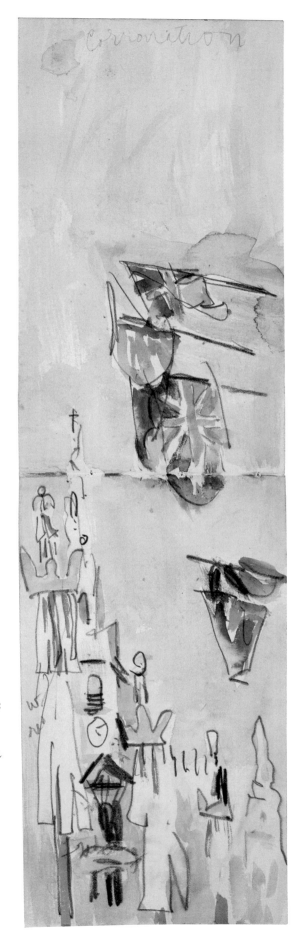

This sketch shows the flags and standards being held up as part of a Coronation procession. Clarke-Hall has chosen to leave out the people; she's angled herself to look up at what they're carrying instead. When this Coronation took place, being there would have been the only way of seeing it live – television and computers didn't exist; film was made without sound.

BREAKING BOUNDARIES

A sketchbook should be customised to do what you want it to do. Whatever its limits, you can extend them to suit your needs.

Sometimes artists write lists in their sketchbooks. They might be anything from a reminder to buy the cat food, or an address that they mustn't forget. Romare Bearden is known for the wonderful large-scale collages he made. His sketchbooks are full of collages, but these are collages of ideas – there are masses of quotations from writers, artists and philosophers, as well as his drawings, all mixed up together. Sometimes, as you are working on a picture, an odd thought comes into your mind and stops you concentrating properly. Write it down so that you know it's been stored away, and your brain is free to concentrate on what you're doing. (If you've ever had a sleepless night, you may know that the same thing applies when you're trying to let yourself get back to sleep: write it down – whatever it is – and forget about it until the morning.)

You can collect or make envelopes or bags and staple or stick them into the sketchbook: for instance, you might want
- to keep things that won't lie flat on a page
- to fold up and store an image that's too big for a page
- to be able to move something around in your sketchbook, e.g. a postcard that you want to look at alongside work from several pages (see page 23)

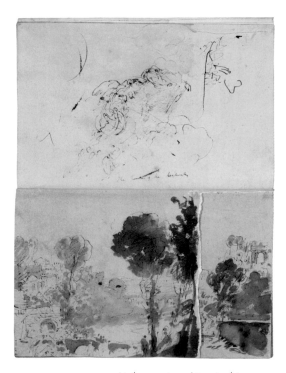

Turner could be so painstaking in his sketchbooks, but here a third of the page is torn out. Why?

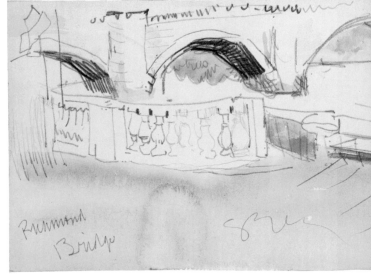

Think of standing beside a straight bit of river and looking towards the horizon. Clarke-Hall has swivelled the river around 90°, and treated the bridge across it as the horizon. To do this, she's also turned her sketchbook around 90° and drawn across two pages.

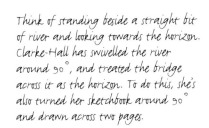

These Canadian artists, Janet
Cardiff & George Bures Miller,
were preparing for a work trip
to London.

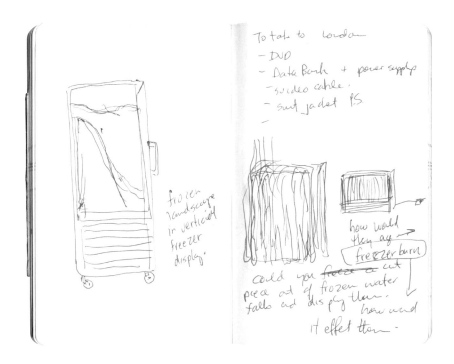

To take to London
- DVD
- Data Bank + power supply
- s-video cable
- suit jacket P.S.

frozen
landscape
in vertical
freezer
display

how would
they say
freezer burn

Could you freeze a cut
piece out of frozen water
falls and display them.
how would
it effect them-

You can cut holes in paper because you
want to see through several pages.

You can create a textured surface to
draw or paint on (sand and glue, or acrylic
gesso, or **PVA** glue, for instance).

You can try combining media to see
what'll happen.

And by juxtaposing odd things you can
come up with new ideas.

Gaudier-Brzeska cut a hole out of
his page of heads. It's so deliberate,
he must have had a good reason.

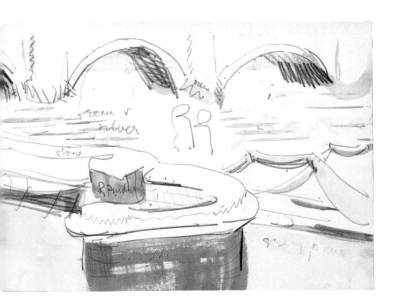

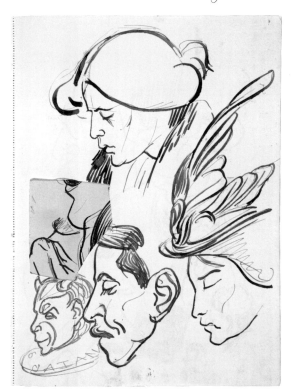

11.2.10

I didn't have Venetian or Indian red colours when I was in the gallery so I coloured in with come back at home

It was really difficult to draw this person because there's so much intricate detail, like a jigsaw. This painting was made after a suicide, + after a death like that people are left to try + piece together what happened.

these hands have the feel of

hanging on, clutching (especially his little finger shape)

the negative (black bits) between the toes is stronger than the toes. It looks tense + like an animal's paw. especially with the block of black above the foot

I woke up this morning + realized this is a lump of hair, like a "KISS curl"

In the painting this "gap", looking through to railing + sea, is similar to the diagonal stripes of ... so it takes a long time to 'see' it.

lovely sandy yellow (warm)

venetian red

this leg looks flat, like a cut out paper, a doll (? to be ...

this white line runs all the way up the picture. You can see how I've got things wrong, because ... At top behi...

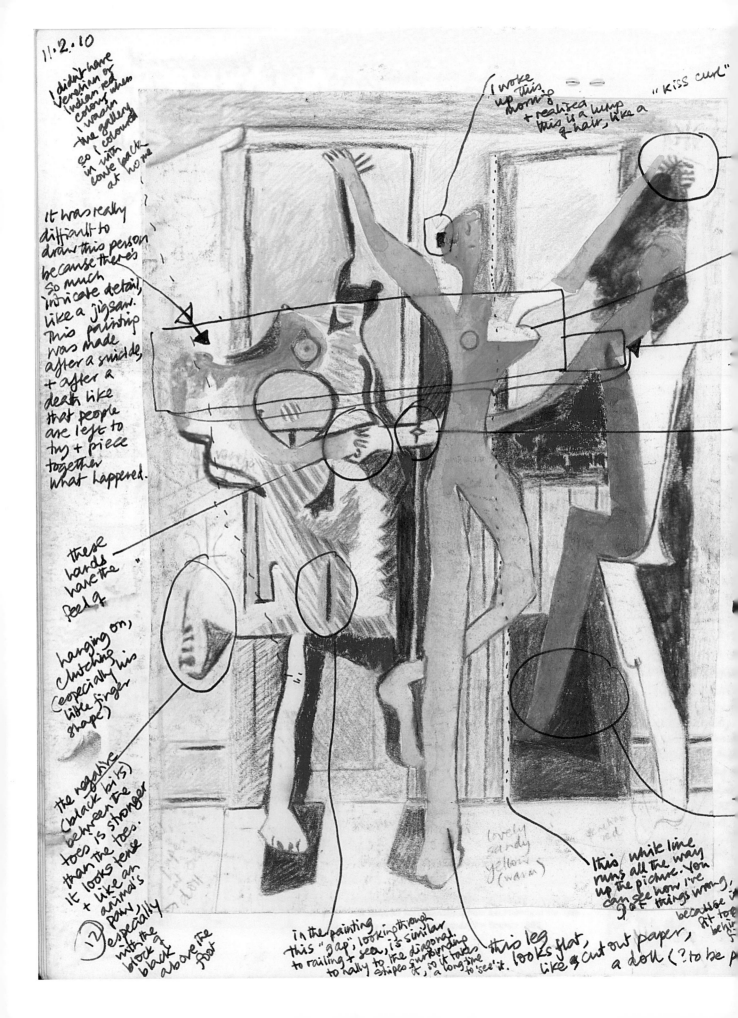

Left margin (partially cut-off handwritten notes):

I scanned the drawing I'd made in the gallery, and printed it so that I could make better notes on it. I stuck it into my sketchbook. The print was poor quality, but it didn't really matter as it meant I could try out different colours and materials: conté, coloured pencil – dry and wet – black ink. Just above the picture you can see the back of two staples that were fixing my paper bag for a postcard on the previous page (see page 23 in this book).

Sketchbooks can be a perfect bridge between new and traditional media, back and forth. Try it.

Make a drawing in your sketchbook from a painting in a gallery. Take it back home or to school and scan it into a computer. Use a photographic software package to explore some ideas you want to follow up on the scanned-in drawing. This can be quite technical, for instance, you might want to try and render the colours more accurately than you could with coloured pencils in the gallery, or you might want to use your imagination to develop your own picture that's inspired by what you drew. Select the ones you like, print them and stick them in your sketchbook.

Do some more drawings from these in your sketchbook.

Notice the difference in the way you feel and the way your thoughts develop, when you're working on a computer with a photographic package, and when you're working in your sketchbook with something soft, like compressed charcoal. See more about how artists use different technologies on page 42. Don't forget to use fixative in the sketchbook, otherwise your drawings may cross more boundaries than you want, and begin to fade or smudge.

As I made the first drawing in the museum, I realised the picture is quite textured because Picasso changed how he was painting halfway through, and so he painted over some dry 'impasto' (thick, pasty, textured) painting. I went home, made a textured surface in my sketchbook using acrylic primer (but you could use acrylic paint), returned to the museum and did a close-up drawing on the textured surface with water-soluble pencil crayons. Not happy with it! I wanted to see what it felt like when Picasso was painting straight lines etc. against the texture. I licked my finger to smudge the crayons to try and make it look more like the painting, but not a great result. (For conservation reasons, museums won't let you use wet stuff in the galleries, so this was the only option.)

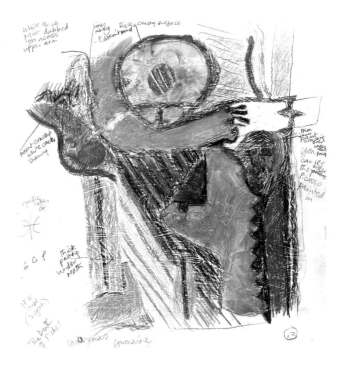

When I did the close-up textured drawing I noticed how Picasso simply didn't care about the lines and edges in his painting, whether they're neat or have sharp edges. Because he's painting on a surface that already has dry paint on it, his new painted lines wiggle over the rough surface, although they're meant to be straight. I left the gallery and saw how splodgy road painting is too, going over old paint and old, bumpy surfaces, although I think of them as neat and crisp. I took some photos on my phone.

Later I remembered this work I saw when I was a student. I hadn't understood it, so I found it intriguing and it's stayed with me, as if asleep, until now. There is no real connection between Picasso's 'Three Dancers' and Mark Boyle's 'Holland Park Avenue study', except in my head. In a sketchbook, though, you can put them side by side, and use this unusual juxtaposition towards something else.

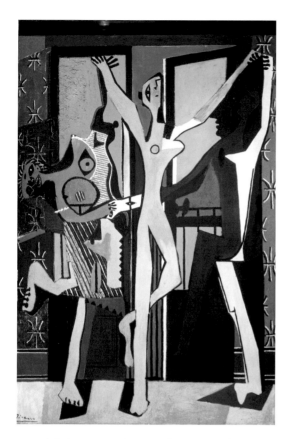

Picasso's 'Three Dancers' printed from Tate Online www.tate.org.uk. It resembles the original work, but it isn't the same as seeing it.

I kept the paper bag the postcard came in, and adapted it so that it could be a kind of envelope for the postcard. It means I can take it out and look at it next to anything I choose.

A note about different media

Drawing from an original work of art – for instance, a painting – is completely different from working from a reproduction in a book, which is different from a postcard, which is different from a reproduction online, which is different from the print-out of the reproduction online. Try to get to an art museum, and make sure you make the most of any information they can give you – always ask what they have to offer. Most have very useful websites that will give you information you can trust.

Each reproduction of a painting is likely to show different colours and tones (light and shade). The scale will be completely different from the original. The original will probably be hanging against a plain wall, whereas each of the others will be surrounded by 'stuff' – for instance adverts (online), your own stuff (postcard), text and other pictures (reproduction in a book). The visual context will affect how you see the work. And only the original will give you the *feel* of what it's made of, even without touching it.

Remember, too, that your eyes are fantastically sensitive, and so are the artist's. So the artist will have made something complex and sensitive and, looking straight at it, you'll be able to see this with your complex and sensitive eyes. A camera's lens, and the screen of a computer, can't do this – they can't unconsciously and at lightning speed move in and out of focus, or see the periphery and the centre apparently at the same time. That's what eyes can do, yours and the artist's. Equipment is equipment – it does what it says on the box; eyes do more than we real-eyes (realise – get it?).

MAKING A MESS

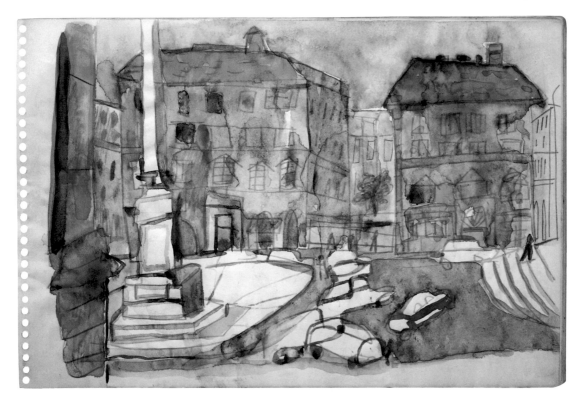

Bearden allowed his watercolour to run. Did he spill water on it, or was it raining in the Venice square when he made his sketch?

One of the real pleasures about a sketchbook is that it doesn't matter if you make a mess. You don't have to clear up, you just move on to the next page. In fact, sometimes making a mess can lead directly to new creative thinking.

When is a mess creative?

When it's helping you work out what you want or what you like – making a mess or something you don't like can help you identify what you *do* want to do next.

When you're concentrating hard on getting one thing right, and you forget about other things – it can lead to you making something really good.

When you use it to try something new – you've got nothing to lose.

When it's a result of an experiment – perhaps a new technique.

When it's a result of you making 'free' drawings or allowing your thinking to run free – letting yourself go

can really help you develop a looser way of thinking and drawing.

When it's a mistake – if you don't like it, you can simply, neatly, cross it out. However, you might want to leave it as it is, because it's always possible to learn something from a mistake. And, actually, it's also common to think something's really bad on one occasion and come back to it and think it's in fact quite good. Sometimes this process – changing your mind about something you've drawn – can go on and on, as if on repeat. So just let it be. Remember the first section: don't censor yourself. And look at page 27 to see how many 'mistaken' lines Picasso made in these drawings.

Sometimes concentrating on making things neat can inhibit your development. There is a time and place for neatness, and a time and place for mess. You only want to start concentrating on making something neat when it's near the final stage. Before that it's important to let yourself do the drawing or thinking in your own way, to suit your own temperament or interests. Some people

are naturally neater or messier than others. REMEMBER TO BE YOURSELF IN YOUR SKETCHBOOK – it's a reflection of you. Allow yourself to feel comfortable with the way you are, and that includes physically. If you concentrate too soon on making things neat it can stop you finding out new things – your creative thinking – through your drawing.

This is part of a great landscape sketch Edna Clarke-Hall made over another drawing that she must have decided wasn't worth keeping.

What to do with a mess?

- Turn over and forget about it (but if it's wet, or dry like conté or charcoal, it'll imprint itself on the page opposite – do you want this? If not, blot it or wipe it or fix it first).
- Cover it up with something – stick something on it or paint a new surface, so that you can create something directly from the fact that you made a mess.
- Cross it out SIMPLY, to indicate a decision you've made, and so that it's clear that it's not what you wanted.
- Leave it alone, move on, and promise yourself to look back at these pages later on, so that you can reflect on it, maybe to find a use for it.
- Make something of it – turn something that's gone wrong into something you wouldn't have thought of without it.
- Carry on as if it isn't there.

It is the PROCESS of making, observing and thinking in your sketchbook that's important. The result – the PRODUCT – of your sketchbook work will be the things you make outside of the sketchbook – the book, the model, the sculpture, the film, or the painting. Making the sketchbook is the process that informs your development towards making the final work. This process reveals to you what you want to do, and the finished sketchbook reveals to your audience or teacher or examiner how you arrived at deciding to make the final work as it is.

Therefore the sketchbook, when you've finished it, is the result of the process, it isn't the object in itself (the product).

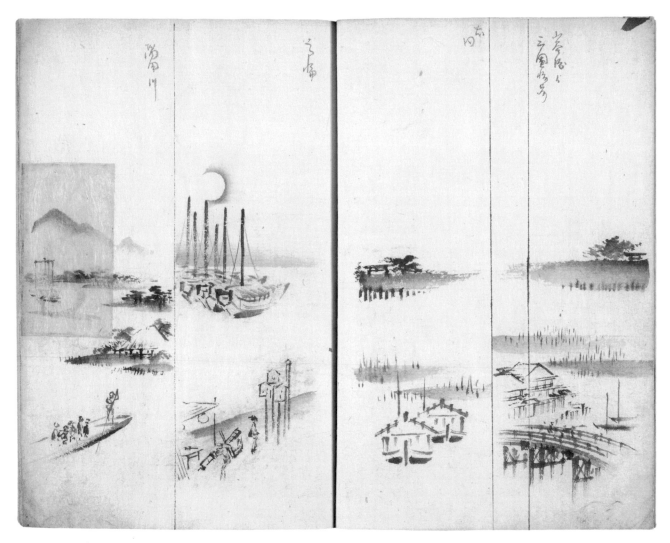

Utagawa Hiroshige was a very fine Japanese artist, and his sketchbooks show an emphasis on making high-quality, perfected drawings. The sketchbooks he used contained handmade paper – he ignored the patch ...

All your drawings – your entire sketchbook – is full of decisions. You decide to draw a line here, or not to draw a line there, to write a note beside a picture, or to make a series of pictures with no writing. A sketchbook is also full of possibilities: assuming you don't develop every doodle or drawing into a full-scale work of art outside your sketchbook, all those left are full of unrealised potential. Therefore you are constantly making decisions to let things go, to leave things out, not to develop ideas. So you don't actually need to cross anything out, unless you want to indicate that you're angry. Or you want to keep something private (see page 5).

Or you can turn the ghost of the drawing (on the reverse page) into another version.

How to avoid making a mess without getting too obsessive

Tuck a piece of blotting paper inside a cover of your sketchbook and use it on ink before turning over. However, sometimes, if you're using dip pen and artist's ink, you might want to put it on thick and leave it to dry because you like the texture.

Alternatively, have some paper towel to hand.

Have fixative nearby so that you can fix a drawing – even a pencil drawing – as you go. If it's a drawing you'll be spending a long time on, it's easy to rub it with your wrist as you're drawing, so watch out for this. The softer the pencil the more easily it will smudge (which you can use to good effect). Definitely fix charcoal, conté, and pastel.

If a page is wet – maybe you've used watercolour – and you want to turn over, you can dry it with a hair dryer, or take it for a walk around outside for a few minutes (be careful to keep the page flat so that the paint doesn't run).

Make sure any glue you've used is dry before you turn over a page! If you can't wait, turn it over but insert a prop, a ruler perhaps or a pen, to keep it separate.

Leonardo da Vinci said, 'Art is never finished, only abandoned.' Don't feel you have to 'complete' a page. Sometimes you need a gap to give you room to think.

Look closely at the four different drawings Picasso made on this page. Look at every outline to compare them. And look at the way he's used different types of small lines (cross-hatching) to create a sense of volume. Some of these look like scribbles. But can you work out which of these lines might actually be 'mistakes' or covering up 'mistakes'?

STICKING WITH IT

Are you sticky? Can you stick with it even when the going gets tough – when you stop believing you can do it? Answering yes to these questions reveals a key feature of a strong sketchbook. Creativity demands that you, the artist, stick with it. Otherwise all your ideas come to nothing.

Sticking with it is Tenacity. Or Endurance. Or Doggedness. You're not born with it, it's something you learn and the best way to learn it is by repeatedly forcing yourself to stick with it. You have to train your own will power to make yourself carry on even when you're bored or you feel you can't do it – or both. The surprise is that, when you've made yourself stick with something once, you push through the pain barrier, and you come out the other side with something you're pleased with. It's weird and you'll never believe it until you do it, but if you try it you'll find it's true. If you make yourself do it once,

you can do it again. And every time you make yourself do it, you're building up your will power. With strong will power – determination – you can achieve anything.

Interruptions – and responding to them – are the best way to fail to stick with your sketchbook. A sure-fire way to do mediocre work is to try, at the same time, to keep your networks going on the computer, or talk on the phone. Doing mediocre work (and being distracted by friends as you work) will leave you bored. You won't want to do any more. To get the sketchbook really working, you do have to give it time and concentration. The only exception to this is if you're trying the Doodling technique (page 6), but this should be occasional, not normal.

When Michael Landy was meditating about consumer goods turning into rubbish 'now stripped of the features that once made it desirable' I suppose he didn't have his notebook to hand – or perhaps this was from another time, and he was thinking about something else. In any case, he wanted to stick it into the notebook in which he was developing his Art Bin ideas.

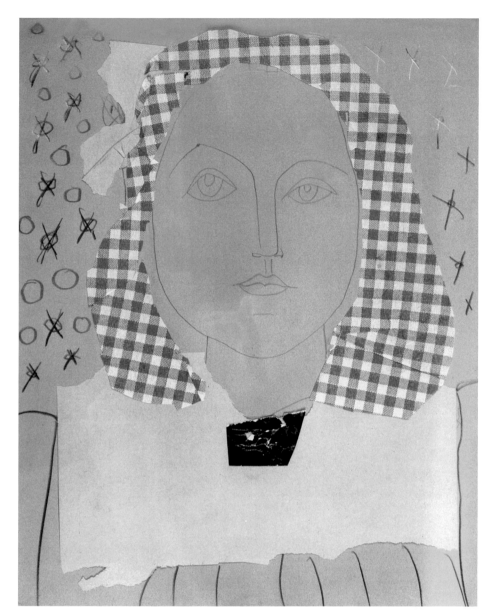

Look at the different types of material Picasso used to make this portrait. Gingham hair: what does it remind you of? Think about why he has torn, cut, or drawn; or why sometimes he's used paper and sometimes cloth.

Another kind of stickiness

But sketchbooks are also great for sticking things in. Picasso (and other Cubist artists such as Georges Braque) focused attention on collage in fine art (pictures that include different things stuck together). Sticking things together in pictures and writing had been developed with the invention of paper centuries earlier, and scrapbooks are a common feature in early childhood. Sketchbooks offer great opportunities for trying out different types of collage. A sketchbook is, quite often, a book made up of different fragments, pulling different types of things together – drawings, photographs, images and texts from magazines or downloaded from the internet … and so on. You can tear things out from your own sketchbooks and stick them back in again to rearrange them.

Stapling, glueing, taping (in all its varieties), binding, sewing – there are numerous ways of sticking things in. Or you might want to add post-its as mobile notes and reminders, depending how you want to see it and what you need to be reminded of.

By putting unexpected things together you come up with new images and ideas. Try it!

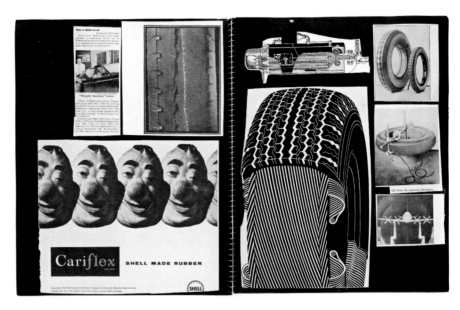

Paolozzi compiled these pictures – from trade magazines – to develop visual ideas. Both a sculptor and a printmaker, he put these pictures together thinking about tyres as machines that make prints (look at the 'prints' in the mud), as well as their sculptural qualities – the weight, the feel, the way they were made. He was also interested in consumerism and advertising, the way images of people – perfect happy couples, or voluptuous cartoon women – helped connect with consumers' dreams to sell ordinary products.

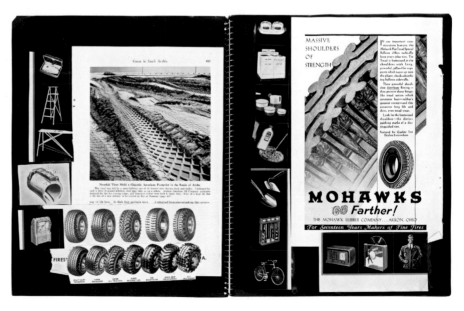

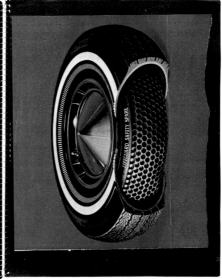

WRITING

It's called a sketchbook, but you write in it. Why?

Ten reasons why you might write in a sketchbook

The first three might be unexpected – they might not seem to be part of your work, but they are part of the PROCESS of making your work. The other seven are much more predictable. Artists do all of them – you'll find examples of the following list in the sketchbooks included in this book.

1 To offload thoughts that keep interrupting your concentration – shopping lists, to do lists, friends to text, etc.

2 To remind you of facts you need to remember – contact details, appointments, etc. – so that you don't have to keep them in mind.

3 Your diary, or things about your life that you want to write about. Sometimes you feel the need to get something off your chest so that you can really concentrate on the work you're making.

4 To write down a flow of ideas – sometimes drawing, sometimes writing.

5 Notes to help with technical issues and the process of making something – how to use a printing technique, making a stretcher for a canvas and the lengths of wood needed, stretching paper for watercolours, etc.

6 To write your thoughts about a work of art, or ideas for its title as you're making it: this helps you develop the work.

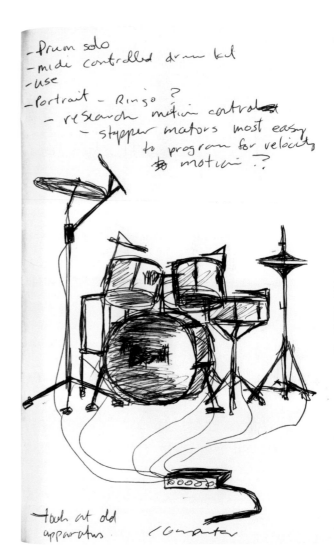

Janet Cardiff and George Bures Miller are reminding themselves here to 'look at old apparatus', and 'research motion control'.

Edna Clarke-Hall was writing this about a century ago. She had already drawn and written on this page but felt she needed to make a note or a kind of diary entry and squeezed it in. Why do you think she wanted to write it down? '… peasants or gentlemen, their manners were atrocious … they sat eating & drinking our tea & eating our cakes helping themselves freely & talking about themselves among themselves as if we were not there … now & then listening to Dora's loud chatter. I stood by amazed and amused.'

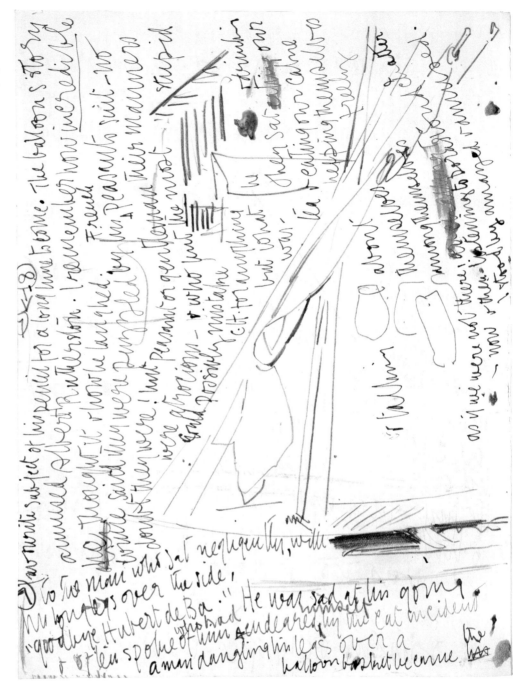

7 To refer to other things you're studying (for instance, a work of art – in the broadest sense – such as, a film or a novel, or an event in history, or a scientific element). Or it could be something completely different that you find yourself thinking about. You may not see the connection with the work you're making at first, but you often do once you've written about it. It could be a film, a TV programme, a piece of furniture or a building – anything.

8 Ideas for work you want to make in the future – ideas generated by the work you're currently making.

9 To quote other people's writing that you find connections with – these can be brief phrases or several pages long.

10 To label or speed up the process of sketching in your sketchbook – for instance, writing in the colours if you only have a lead pencil with you.

Look at all the pages from Cornelia Parker's notebooks (also on pages 4 and 45) to find the themes and references that run through them. Notice how she thinks about colour, weight and substance in words or phrases like 'silver' or 'jet', and then she thinks about what she can do with them 'cover object ...' Check out the variety of sources she's using, including the 'Science Museum'.

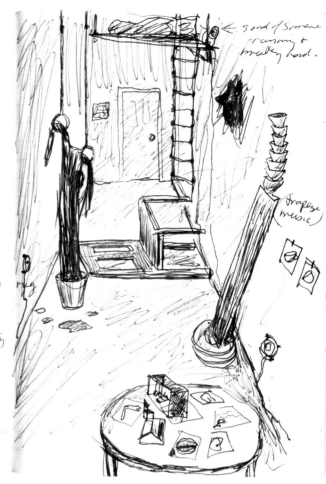

Cardiff and Bures Miller here
write dialogue as if for a play,
possibly to be recorded as part of an
installation they plan to make.

Michael Landy writes brief notes and draws
diagrams to work out ideas for a major
installation ... 'compact it', 'pick it up', 'walk
on it', 'art mountain', 'art that nobody wants'.
He's a brilliant draftsman, but he's choosing to
make these drawings as simple as possible. Why?

Storyboards

Artists make storyboards if they are making something, like a film, that involves a sequence over time. A bit like comic strips, different shots make up a scene with notes alongside describing in words what happens in each frame, including the position of the camera, sounds occurring, light and shadow changes, and movement within the shot. You might find it helpful to make storyboards for other ideas, not just films – such as a team project to make an installation, a plan for developing a sculpture, or simply a comic strip.

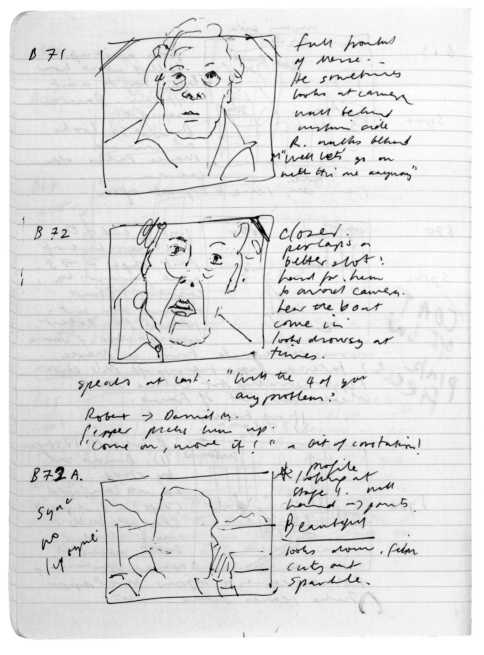

Tacita Dean makes films with physical film stock (that is, they aren't digital). The pages illustrated here are from what she calls her 'cutting books'. Unlike storyboards, which are made in advance of filming, she makes them after she's shot the film, in preparation for editing it. She looks at all the film, noting everything down, shot by shot, sequence by sequence: the cutting books become her guidebook to the content. She cuts on a Steenbeck (a type of film editing suite) which, as she says, 'means you rely on your notes enormously, as you just have piles of reels, or a basket of strips, and you can't distinguish one shot from another'. Note just how much information she is gathering for each shot: what is filmed, how it is filmed, and sometimes a note to herself. Why is 'CREW EVERYWHERE' in capital letters? Tacita Dean's writing complements her drawings – some are close up (the first portrait shots of the dancer and choreographer Merce Cunningham), and some are landscapes.

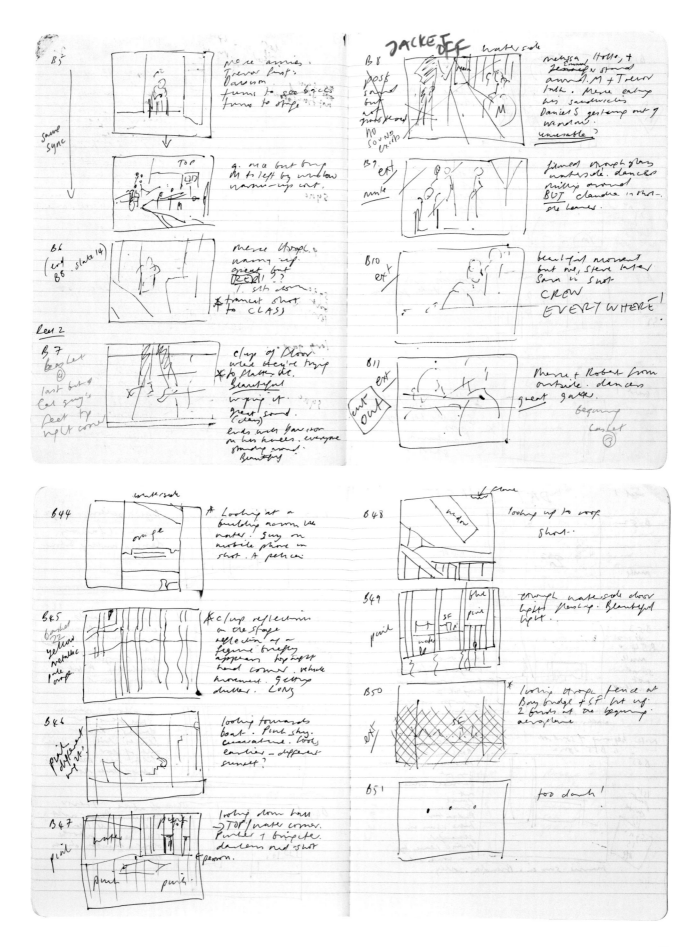

COLLECTING AND CONNECTING

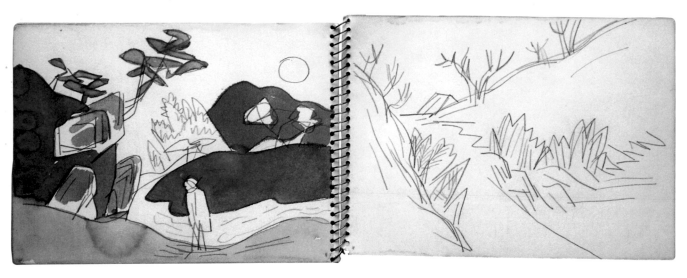

Some artists compose their sketchbooks with a range of thoughts and images expressed in several ways. Is it a good idea to make your sketchbook like a magpie's nest, with all sorts of glitter and colour? Only if it has a purpose. When you collect, what you leave out is as important as what you put in. Don't forget, making art is all about decisions, and the sketchbook is about editing as you go. It can also be seen as a place to store ideas, many of which you won't necessarily develop.

On the one hand, don't censor yourself. On the other, make choices: work to refine and develop your ideas.

Bearden only painted colour in part of this landscape – it looks as if this was enough information.

Two pages of one of Monet's sketchbooks, both of boats. Look at the space in the left-hand page, and the pool of boats on the right.

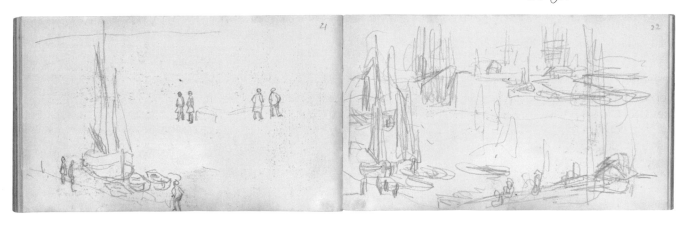

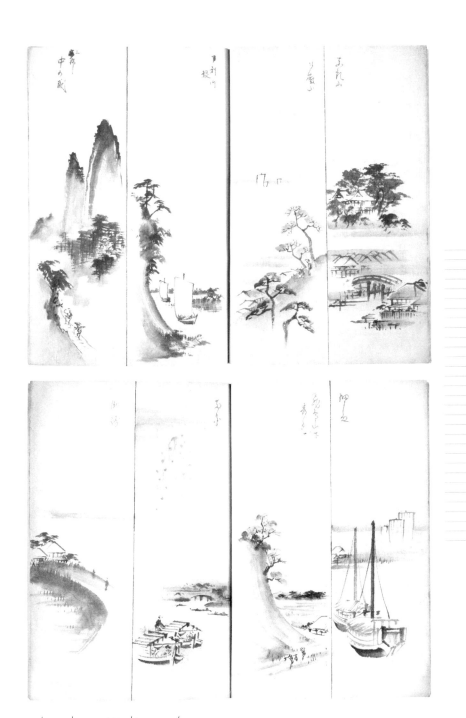

Look at the way Hiroshige uses the blank paper in his sketches.

Janet Cardiff and George Bures Miller left the empty space around this person to make them appear marooned on the ladder.

Range

Consider the range of what you include in your sketchbook. Does it have purpose? How is it reflecting the range of your thinking? Could you extend the range, or would your work benefit from narrowing the focus? Broader or deeper? As you build your sketchbook you will start to make choices. Something you'd include in the first few pages you may decide to leave undeveloped.

Sometimes you include something only to find you don't want to take it any further – it's not useful at the moment for the way your ideas and your work are developing. It may, however, be something to pick up another time. A sketchbook habit can become the habit of a lifetime.

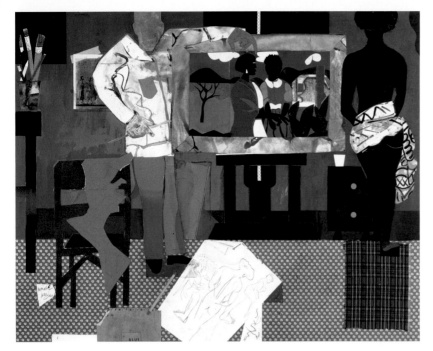

Bearden is known for his collages, but he didn't make them in his sketchbooks. He did take a page from his sketchbook and stick it in this collage though.

Very occasionally Bearden stuck something in his sketchbook He also drew on odd leaflets, programmes and so on, and then kept them with his sketchbooks.

Collage

Collage is a particular form of picture-making that became a feature of twentieth-century fine art. It had a number of different aims. One was to bring together the 'everyday' (e.g. newspapers) with the precious (e.g. fine or 'high' art). One was to bring together images to form some sort of collision – possibly through what they looked like (colour, form, etc.) or through what they represented (e.g. images of war juxtaposed with images of babies). Artists tore or cut images from magazines or newspapers and stuck them together to make a single picture. Sometimes images were created into a montage – they were moulded together to form an apparently seamless picture. Nowadays software packages enable you to do this without anyone knowing. You have to choose whether or not you want to show that you have made the image from several others.

Do you want the **feel** of the collage to make a **tactile** connection with the viewer?

How are you **selecting** images to go into your collage?

What visual references do they bring with them (e.g. documentary, news, advertising, scandal, cultures, religions, geographies)?

Do you want to **credit** the artists (famous or anonymous) whose pictures you are using?

Do you want to risk **plagiarism**?

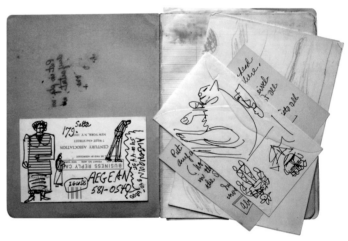

Repetitions

Sometimes artists use repetition to explore an idea, or to create a new meaning by repeating the same or similar images over and over to create a new single picture or sequence. Andy Warhol famously did this. Online museum and gallery collections like Tate's (www.tate.org.uk/collection) are a good source for authentic, high-quality information and images, such as Warhol's *Marilyn Diptych* 1962. (Be careful using search engines as a source for your images because you can't be sure they're authentic, legal or credited to the right artist.)

What does an artist do to the meaning of a picture by repeating it?

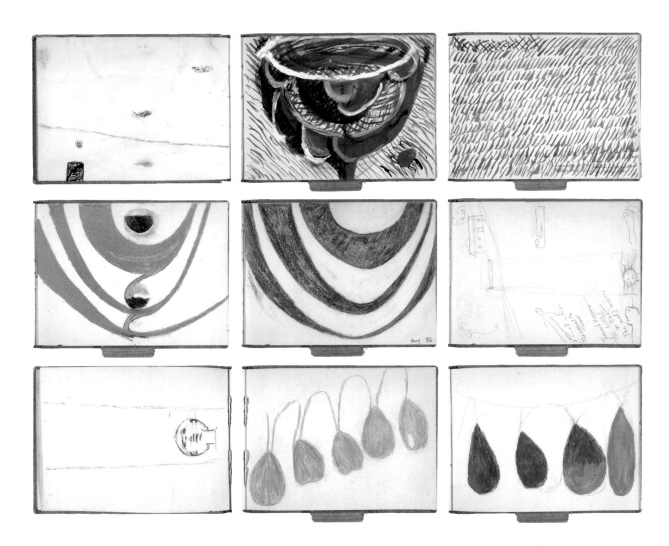

Look at this sequence of pages from one of Louise Bourgeois's notebooks to see how she develops her ideas. It seems that there are at least two lines of thought.

Developing ideas

Check the list of artists on page 48, and then track each artist's sketchbook pages throughout this book to see how they develop their ideas.

Unusual juxtapositions

So far this book has listed many different things that might go into a sketchbook (shopping lists, ten types of drawing, contact details, painting, your own writing, collage, photography, other people's writing, etc., etc.). Looking at them together is one way to fire off creative sparks in your mind. By placing things side by side that don't normally go together you can get new and original ideas for making works of art.

21ST CENTURY ARTIST

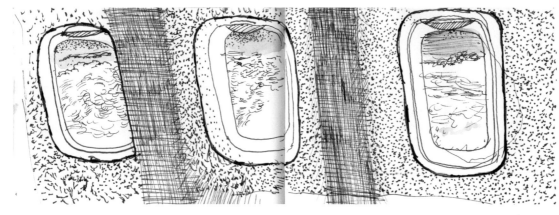

Are we there yet? Hockney is spending time drawing, enjoying the journey. A camera would have recorded it much quicker, but so well?

You are making art in the twenty-first century. You have a massive variety of possible techniques and technologies open to you. Why use a sketchbook now?

'I took up sketchbooks that fit in the pocket when I stopped looking through cameras. You have to carry the sketchbook in the pocket – any moment I can use them – better than a camera. I had just been given a beautiful new Leica M7. I told a Leica admirer, I had moved on to the M8, a brush in my pocket.'

David Hockney, *Fifteen Sketchbooks*, London, Iceland, Norway, Los Angeles, 2002, 2003, dvd

David Hockney is known not only for his painting and drawing, but also for his pleasure in experimenting with photography and computers. However, he chooses to continue to use a sketchbook.

Around a television people are likely to sit reasonably still: it's a good opportunity to draw them. Derek Boshier has made a series of sketchbook portraits from people *on* the television.

Three of these four portraits are composed from several different people Derek Boshier saw on television, one way of dealing with the constant movement on screen.

Anish Kapoor drew his ideas for Marsyas, a sculpture that filled Tate Modern's famous – and enormous – Turbine Hall, in his sketchbook. But he also used computer generated images, with a range of architectural and photographic software, and maquettes (sculptural models) to develop his ideas. All of it was important. You can see pictures of the final installation if you go to www.tate.org.uk/modern/exhibitions/kapoor/images.htm.

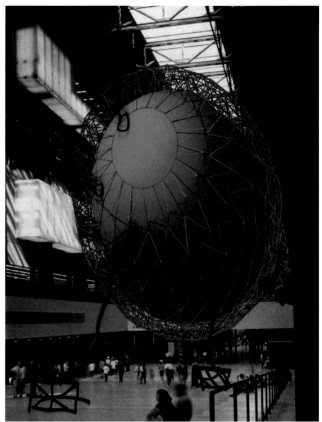

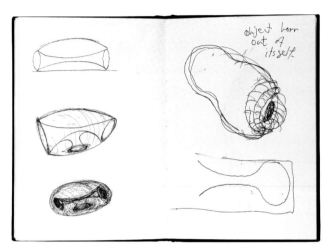

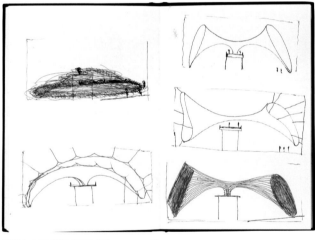

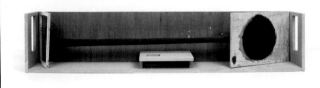

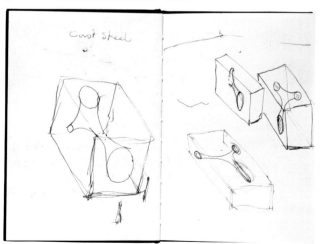

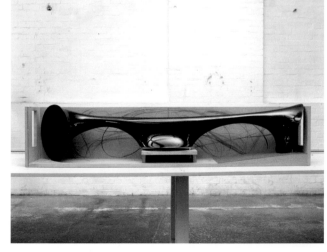

Cornelia Parker makes installations, sculptures, works on paper. She tends to use a notebook, as well as sources such as the internet, to develop her work.

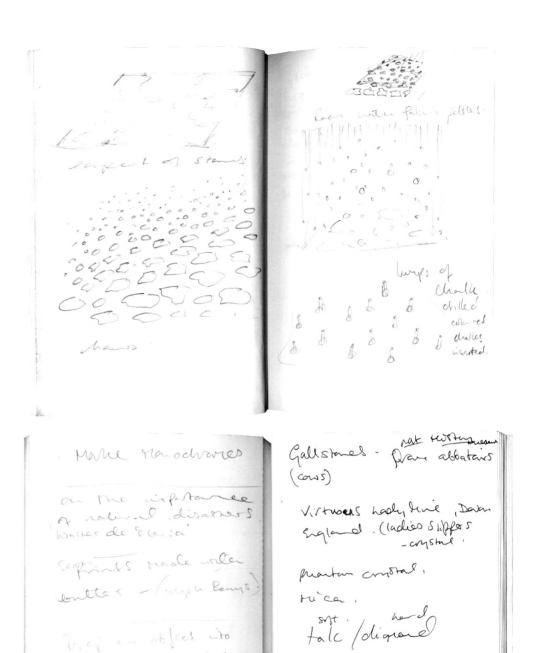

If you should forget to take your sketchbook out with you, but you have a phone, you can write notes and take photos to transfer into your sketchbook later.

There are many good reasons for keeping a sketchbook, and it is vital that you adapt it to what suits you best.

Sometimes the best way of working out ideas is by having a conversation and, with a sketchbook, you are creating a continuing dialogue – whether in writing, drawing or collecting – with yourself. You can play around and tell each other jokes too.

REFLECTION

When you look in the mirror you see a picture of you as you are now. When you look in your sketchbook you see a picture of you, where you've been and where you're going.

Looking at your sketchbook is essential. If you don't look back at it you lose most of what you've done. If you do (over time, not just once) you multiply what you can get out of it. You can look back purposefully or simply amble through it, like taking a stroll through an art museum.

Looking back helps you to
- make new connections
- remember things you've thought or made that you've forgotten, so that you can use them now and in the future
- see the development of your thinking, which helps you to the next stage
- check your drawing to see what you've done well that you want to develop
- find references you've noted to check, so that you can follow them up
- remind yourself of how much work you've put in to give you courage to go on
- stimulate you when you're stuck

Annotation
Making a sketchbook is often a requirement for school, and you will be asked to 'annotate' your work to show how your thinking has developed. However, annotation can be the kiss of death to a lively sketchbook if it's done badly. Look at how the artists shown in this book have 'annotated' their work: as they go along. You may be asked to annotate your work to encourage you to look back at the sketchbook, to show that you can recognise what you have learned. If you give yourself the freedom to write your thoughts as you go, you will show your reflections. Equally, if, every so often, you write a note to yourself that reflects on what you're doing, you will be in good company, along with many of the artists here. It will be like naming a picture, or creating a point of punctuation. Don't forget to let the rhythm of your sketchbook live – don't mask it with weak annotation.

A sketchbook is truly interactive. It goes Thinking, Action, Thinking, Looking, Thinking, Reflection, Thinking, Development. Sometimes the Thinking is woven into

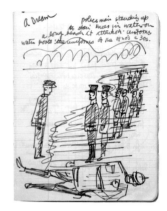

In his sketchbook Romare Bearden notes his dream, of police standing in water. Later he writes and illustrates a book about L'il Dan. It looks as if the sketchbook dream image stayed with him, and he adapted it for the book.

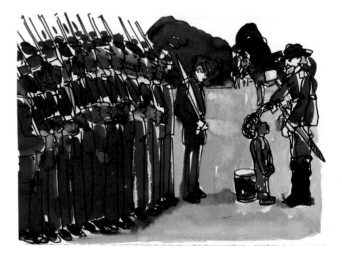

the action-looking-reflection-development, so you don't notice you're doing it. Mostly you don't notice you're doing any of this, but every so often you might want to check that you are, just to make sure you're making the most of all the work you're doing with your sketchbook.

When you go out, and you're annoyed with yourself that you've forgotten your sketchbook, that's when you know you've truly developed the sketchbook habit.

And when you can show your grandchildren your rows of sketchbooks, you'll know that you've developed a sketchbook habit for life.

It's one of those rare habits young people acquire that is extremely pleasurable and, as far as anyone knows, only does you good.

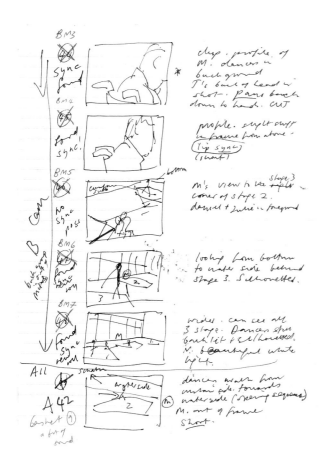

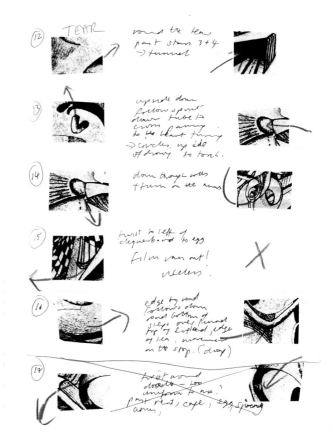

Note how Tacita Dean uses different coloured pens to indicate different stages in the process of her work – she can look back at it and know which decision or comment is the most recent according to the colour of the writing. She's working on a film about a doodle in the right-hand cutting book. She cut up images of the doodle to describe each shot and stuck them in her book; this was easier than drawing the different images because each one was so similar.

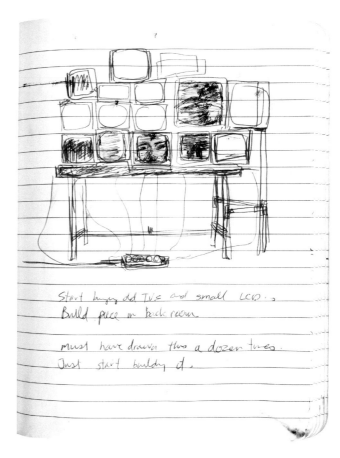

You can see from this page that one of the Cardiff & Bures Miller team is frustrating themselves: 'must have drawn this a dozen times. Just start building it'. Writing instructions to yourself can be useful!

CREDITS

First published 2011 by order of the Tate Trustees by Tate Publishing, a division of Tate Enterprises Ltd, Millbank, London SW1P 4RG
www.tate.org.uk/publishing
© Tate 2011

A catalogue record for this book is available from the British Library

ISBN 978 1 85437 969 6

Distributed in the United States and Canada by ABRAMS, New York
Library of Congress Control Number: 2011924277
Designed by Park Studio
Colour reproduction by DL Imaging Ltd, London
Printed in Hong Kong by Printing Express

Front cover by Felicity Allen
Back cover: David Hockney, *Sketchbook*, London May–June 2002

Acknowledgements

Thank you to those artists who have generously allowed me to reproduce extracts from their 'live' working books – in particular, Derek Boshier, Tacita Dean, Michael Landy and Cornelia Parker. Thanks, too, to all the artists whose sketchbooks are reproduced, and the archivists who have enabled me to retrieve them. Many have helped in different ways: Carri Mackay and her late tutor Cheryl Meszaros, Sarah Culshaw, Mary Stacey, Fiona Bradley, Daniel Herrman, Toby Tannenbaum, Diedra Harris-Kelley, Sheila Rohan, Julia Beaumont-Jones, Pascale Guychard, Claire Owen, and archives including the Getty, the Romare Bearden Archive, the Royal Academy, Tate, the V&A, the British Museum, and the National Galleries of Scotland. I am very grateful for the tact, humour and professionalism of the publishing team – Nicola Bion, Roanne Marner, Miriam Perez, and Linda Lundin at Park Studio – and for the support of former Tate colleagues. I also wish to thank Tate's visitors, especially those young people and their teachers whose engagement with Tate has contributed so much to my – and Tate's – knowledge. Warm and critical input from Stanley Allen, Dorothy Pickard, and Simon Smith has been vital.